# exercise BOOK

## DIRTY DOODLES

THIS IS A CARLTON BOOK

This edition published by
Carlton Books Limited
20 Mortimer Street
London W1T 3JW

Images copyright © 2007 Ross Adams
Layout and design copyright © 2007
Carlton Books Limited

This book is sold subject to the condition that it shall not, by way of trade or otherwise, be lent, resold, hired out or otherwise circulated without the publisher's prior written consent in any form of cover or binding other than that in which it is published and without a similar condition including this condition, being imposed upon the subsequent purchaser. All rights reserved.

ISBN 978-1-84442-225-8

10 9 8 7 6 5 4 3 2 1

Printed in Singapore

Thank you: miss boakes, luke + roland, the family, parker, lamy, normal and you.

# DIRTY DOODLES

Create your own Smutty Scribblings,
Pervy Portraits and Deviant Drawings

From the twisted mind of Rose Adders

CARLTON

Draw in this book

Colour in the images

Fill in the drawings

Stick things in it

Fill the pages with emotions

Cover the pages in liquid

Punish the pages – they've been naughty!

It's your book . . . use it!

Who's blocking YOUR sun?

What could you measure?

Is this something you didn't know about your parents?

# What could these be?

# What are you spying on?

Give this guy a handful

Make an animal from this

Nice shoes!

# Finish the flasher

Get the cock to the crackers...

# Lines and lines and lines and lines and lines...

Journey to the centre of...

# Alien eyes or funny fruit?

# From a different dimension

Eeeeeeeeee splat!

# What's popped out of the magic hat?

Q　　　Draw your queen　　　Q

Q　　　　　　　　　　　　　Q

# Make your own jigsaw

Is that a pistol in your fist?

# What's this wobbly roundshape?

# Where was the chopper dropped?

# Complete the pointy instrument

# Make your own stamp

Udder dog or cat's bum?

What's going on in this bed?

What do you think is dangling overhead?

What's stuck in the fishnets?

# What sort of creature is this?

Are these faces, pills or bulletholes?

Are you off your trolley?

What's your sign?

# Give the skeleton a bone?

# What's in the boot?

# Have a butcher's hook at this!

Half-man, half-?

# What could these be?

Twins?

Can you make something out of this?

It's a wabbit!

Where does food come from?

# What's this little birdie saying?

What's packed like sardines?

Who the hell is that?

Silhouettes...

# Hey, ugly dude

Give the horse a magical horn

Draw your old school wall

Paint the bowl

Life drawing class

# What's on the operating table?

# Something under the table?

# Who's chewing on the new sweety bar?

# Tumblers!

Complete the toolbox

What's up Big Ben?

# What else has been sucked up?

Who's the dogsbody?

You found an old polaroid

What's been left in the rock star's dressing room?

# Hang out your dirty washing

# Who's hanging out in the park?

Have fun on the slippery slide

Draw the shadows

**Save Dave!**

Dave needs a relaxing seat

# What has grown wings?

Finish off the exotic dancers

What's the frog catching?

# Scary shouting old baglady!

Who's in nappies?

Eurgh!

You will obey!

Cut something

What is Dave up to?

Ug, my brain hurts

# Help fatty perform the Nutcracker

Is that a Mexican hat?

Who's in chains?

# What is Dave riding?

Who's in the red light window?

# What's happening on the back seat of the bus?

# Fill the fruit bowl

What's in the case?

What's swinging in the park?

Draw your own cartoon character

**Sew the head back on your favourite teddy**

What are these?

○   ○   ○   ○

Draw your own customized personal stereo

Join the dots?

What's this?

# Is there something inside?

# Draw a big balloon ride

Finish the key

Bombs away!

What are you playing with?

**What were you drinking last night?**

Where's this been?

# What's weighing?

What's the ad for?

# Who's getting battered around the ring?

VS

What does this measure?

# Finish these people off

# What's come from beyond the grave?

# What's on wheels?

# Start daydreaming!

# Can you draw a man in his birthday suit?

Can you draw a woman in her birthday suit?

# What's in the tank?

# What's behind bars?

Eek! Alien moment!

Do you lick what you see?

Who's wearing the cape?

What's on the film strip?

What's on the tv?

# What are these guys moving?

Is that a candle?

What's in the bag?

# Storyboard your film:
## The opening sequence...

...the characters...

...the plot unfolds...

...the twist...

uncertainty

curiosity

end credit

excitement

the climax

# And the sequel:

...excuses

familiarity

bigger budget...

★ guest stars ★

nudity

love interest...

unsatistfied

What's he watching?

Finish the lady off

Can you make it bigger?

# What's under the newsreader's desk?

NEWSFLASH:

The pauper...

... and the Prince

What does the switch turn on?

# Traffic lights?

○

○

○

# What's on at the gallery?

Complete the totem pole

Draw the new city fountain

Draw your reflection

Draw your dream partner

# Fill in the flag

Draw your own wallpaper

What a mess!

Complete the landscape

Finish the stained-glass window

# Looks like a dangerous adventure

# Add a person to the hairstyle

What's behind the face?

What's been taken in hand?

Seafood

Fish supper anyone?

Shape the bush

# Who's propping up the bar?

Fill in the cubicle walls

# Fill in this holiday postcard for your boss

What laid these eggs?

Nice pear!

What's going on here?

What's for dinner?

Draw something spilled

What's under the sheet?

# Lock 'em up!

What did you eat and where did it go?

Fill the bun with meat

Fill me in

Nice mullet!

Complete the car

# Give the musicians something to play with

What are they thinking?

What kind of show is this?

# Got who in your sights?

What did they leave in the bed?

Make the hat stand out in a crowd

Who's come into the bathroom?

Save the seamen

Draw the latest multi-purpose mobile phone

# Choose the museum's new display

# Fill the receptacles

Plug in your favourite device

# What wants to eat Daisy?

# Fill in the missing parts

# Fill in the missing parts

# Win the wheelbarrow race

What's the best bait to catch mermaids?

# What scared the spaceman?

What's up the ladder?

Decorate Ma's buns

# Draw some new swimwear

# What's going on at stage door?

You made the front page

# DAILY ★ TALE

# The Piggy Bank

Cheque this out

PAY **The Sum of** ACCOUNT PAYEE ONLY

£

DATE

R. ADDERS

*Rosie Adder*